Dementia Painting

The later paintings of **Joan Colnbrook** as documented and assembled by her son
Stefan Szczelkun

ROUTINE ART Co. 2023

Images from this book my be reproduced in research papers or reviews, if full credit is given.
Please let the author know the full reference and a copy of the paper. All other rights reserved.

Hardback ISBN 978-1-870736-94-7

Paperback ISBN 978-1-870736-92-3

First Edition 2023

Routine Art Co. is an imprint of 'Working Press: books by and about working class artists' and is a way of publishing collaborative works.

Preface This book is a collage of various intentions - each of which might appeal to different readerships! * To start with there is the possible use of painting as a means of expression for those with dementia. * Then I have tried to find the roots of my mum's drive to make art in our family history and her mother Daisy who had worked in service. And to go further back to another person who was a servant that became inspired by high art - Robert Dodsley. * My work in general is about understanding how class oppression works through culture - so that is a thread that is woven through this book. * Finally, after reading Tillie Olsen's work, especially 'Silences', I try to appreciate the limitations put on to artists who are working class and mothers; whose ambitions are often realised by their fruits of their womb. So that I am beholden to my mother's passion for art and life.

Introduction

I have two main aims in mind for this book.

The first is make a publicly accessible selection of my Mum's dementia paintings, so those who care for people with dementia can see the progress of my mum's paintings. People in general, whose relatives might have dementia, might be able to see what kind of things are possible with supported painting and at the same time, become aware of prejudices about artistic ability and what a 'good' painting should look like. Many limiting ideas get in the way of encouraging the expressive use of paint. However, what I don't know is whether it was my mother's previous passion for painting that allowed her to use painting in this way. Perhaps, if somebody had never painted in their life, and then got dementia, it might not be easy to take it up even with the best possible support. I'm guessing my mother was able to use this medium of expression and communication readily because she had access to muscular memories that were associated with one of her greatest pleasures - painting . She seems to have been able to draw on this none-intellectual area of memory that may have side-stepped the limitations that dementia can impose on thinking and action.

My second ambition for the book is more to do with conventions that beset and limit amateur artists and the creative thinking of the population in general. Ideas about what a painting *should* look like will often not allow amateurs to create things that reflect their inner being. For instance, viewers will often have expectations of a 'good likeness' and an artist will feel they should conform to these expectations. Once such impediments are swept away we can think about how Art might represent the human predicament through the lens of the artists intuition. In my opinion, evaluating the our human situation is the most noble aim of any cultural activity and provides the highest satisfaction for any artist. For me the social value of art is most importantly to provide *an ongoing reevaluation of our totality*. This is something accessible to anyone with a pencil and paper, once a basic level of technical competence has been achieved. Or perhaps even before this level of competence is achieved, because we are all linguistically and gesturally competent from an early age and 'levels of competence' can themselves become an ever receding goal. There is then the exciting possibility of anyone being able to contribute to the frontiers of culture.

To understand this viewpoint we must be willing to take on a view of art that is not just about the individual artist and her satisfactions; it is not all about the towering genius. It is more to do with collectivities. Have we, in the West, lost the required social connectivity to provide a collective well-spring of creativity to guide our cultural renewal? Artists have been individualised and separated into competing entities to produce for an art market. This idea is now globalised through an expanding art system. Working class artists, that is, any people with the impulse to think in general terms - in critical terms - about the human predicament, tend to be left out of this rarified art world, and so far, we do not seem to be able to organise such a scene for ourselves on our own terms. We have not been able to envisage and then create the support networks and institutions that would be required for this flowering of our 'general intelligence'.

Dementia seemed to allow my mum to step outside of the limitations she had laboured within in her previous art making. Perhaps the freedom of my mum's later works can inspire other amateur artists to be less conventional.

Stefan Szczelkun

Dulwich Picture Gallery - c 2014

Her paintings were often made into cards by cousin Anthony Hall in Bingham.

8

This first set of photos is to briefly show the kinds of paintings that Joan did before she got dementia, roughly in the years 1980 to 2010. They were mostly done in evening classes with the tuition of a professional, art school trained, teacher. The paintings would do well in the Shepperton amateur arts group summer exhibition. She got her pictures framed locally and they populated her house and the houses of her friends.

I feel they were adhering to good amateur painting practices and also to subject matter which was more about painting and drawing competence, than it was expressive of Joan's inner life or her critique of society.

We did have some mild conflict about the content of art as my artwork was abrasive rather than decorative and she didn't like this. It was impossible to conceive of my work going up on the walls or even be shown to her friends. "Why can't you paint something nice?" she would say with a wry smile. For my part I wished she would let go and have an abstract expressionist fall into chaos. Strangely, absurdly, this wish came true in a benign way after my mother contracted dementia.

Only through making this book did I appreciate the cultural forces that surrounded her art practice which would have made any transgression impossible without retreating to 'madness', or some kind of outsider social status. And making this book has also allowed me to appreciate my mum's art in a way I couldn't when I was younger and resentful of her lack of appreciation of my own more radical approach to art.

"I am writing against pressures, impediments, to what should rightfully be the (artists) fullest freedom to (make artworks) about anything - in any sex, voice, style - in accordance with … whatever seeks expression." Tillie Olsen p.251

Here is Joan with Barbara Manwaring in 2014 in the conservatory of her house in Thamesfield Court, Shepperton.

It was difficult for Joan to attend an evening class in the early stages of her dementia so we decided to try a one-to-one support person. We were lucky to find Barbara Manwaring, who was not a painter herself, but proved to be very flexible in the way she understood and supported Joan's need to do 'serious art' rather than an 'arty crafty' play school approach.

First, she worked with Joan in her home in Shepperton, where she could also see the kinds of things Joan had made in the past. Later, she visited Joan in the care home in Walton and continued to support her painting.

The work produced in this first stage, and when Joan first moved to the care home, was not dated.

A postcard collection in the downstairs toilet under the stairs in Thamesfield Court. The representation of women in art - evacuate and cogiTate.

12

Arriving to live at Mayfield House in 2016 she was celebrated as an artist. The 'Colnbrook Corner' was made in the entrance hall. These were paintings she had done in the previous decades in her house - a house which had to be sold to pay for her care. They had already been framed and it was not easy to find homes for them all when we cleared her house. Fortunately, the care home was open to putting up a number of them in the communal spaces in the first years of her stay.

Two of these older paintings were hung in her room. Soon, Joan was busy producing new work in fortnightly sessions with Barbara. Half-a-dozen of these smaller new works were framed professionally and added to the work in her room.

We were surprised how well she took to communal life after being a house-proud housewife for so many decades. Barbara Manwaring's support continued to be vital and the results were looser, more expressive and less self-conscious than the evening class paintings of the previous decades.

By now Joan was unable to articulate memories in words and any verbal communication was becoming very limited.

What was going on in Joan's mind we will never know, but to the outsider it seemed like a miracle that these scenes could appear so eloquently.

The use of matt card frames supplied by Barbara, served well to instantly frame each picture and make them able to be instantly displayed.

They were done in one session of maybe 30 or 40 minutes, which was about the limit of Joan's attention span (in itself quite remarkable for someone with this degree of dementia!).

In the following days the paintings could be discussed with Joan by her carers and visitors and she was clearly proud of them.

Although there was another woman who had been a painter in the home, Joan was the only resident who was, to my knowledge, still productive.

This image was made into a Christmas card to send to her family and friends

Some of the comments on Facebook after I put up a photo of her holding up one of her prettier paintings.

Polenta Lavery
Well done Joan. Still bursting with talent!

Christina Sobey
Just goes to show how important painting is !

> **Stefan Szczelkun**
> When she is working at a painting Her concentration is fierce!

> **Christina Sobey**
> Just as it should be !

Owen Short
WOW!

Stephen Houston
Ta Stefan. I always like what people do to breathe the beauty into life. Your mum sets a fine example.

Wendy Forbes-Buckingham
That's brilliant x

Melissa Hyatt
Your Mum is amazing! xxx

Emmanuelle Waeckerle
Wonderful portrait /hat/painting/celebration of life and creativity!

Pete Gomes
The jaunty hat sets it all off x

Pauline Marshall
I see so much beauty in Joan's expression as I do in the colours of this delightful painting.

Stephen Houston
Mother-love, a two-way bliss, and the added craft of painting, powers this world. Mothers Day never suffices. Boycott it and replace the thing we are relieved from for the other 364 days with much more painting like this

> **Stefan Szczelkun**
> Thanks for all your likes and comments! I know a lot of you don't have your mum's anymore... life is fleeting, but mother-love continues through us all. Here's to the memory of those mums no longer with us and to their love that flows through our lives now.

> **Brandon Spivey**
> Lucky enough to have mine and she is a surrogate mum to a few of my old mates.She looks out for people. Stefan lovely post.

(Text of back of postcard)

Hi Mum,

This photo of you and your painting was an internet sensation. After I put it on Facebook it was 'liked' by 133 people and there were loads of nice comments about your painting. I can read them out to you when I next visit.

Your birthday is coming up soon
love
Stefan X

Joan went to Mayfield House because she was unable to recognise her home and her place in it. Even earlier she had been unable to attend an evening class, even when they said they welcomed people with dementia. It seemed then that painting was completely beyond her receding abilities.

Scanning her paintings made me see them better and closer than I ever did during my visits to Mayfield House. The act of scanning, and then looking at the scanned image on screen, allowed me to see detail I couldn't see in the original.

It is in the quality of the brushstrokes and little details that my mothers intelligence comes alive in the painting and the subject matter turns from what might have been considered 'too naive or simple to have value' to something which displays an uncomplicated sensitivity, perhaps a pathos, perhaps a simple refutation of the expectations of what is a good picture.

Becoming aware of such expectations is not easy. The amateur artist can desire a balanced composition that is beholden to an imagined observer and *their* expectations of a painting, however it seemed like a previous self-consciousness had now slipped away from Joan, leaving a raw relation between artist and the paper surface mediated by the moving brush.

In her last two years the imaginative side, at least in in terms of a preconceived composition from her imagination, was replaced by the simple joy of painting. It was her memory of natural forms that moved her and motivated her to summon up an astounding capacity to concentrate her mind and co-ordinate hand and eye.

She not only found her way back to making pictures but she found a new sensibility. The paintings were radically different from before. In a sense, more her own, more imaginative, more in touch with the joy of the act of painting.

Her later painting were not framed because there was a lack of wall space to accommodate more paintings and to justify the framing costs. The later, more abstract work framed with Barbara's matts, were sometimes displayed on the mantlepiece of the communal sitting room.

But they were not valued in the way her pre-dementia paintings were and we were not invited to add them to the décor of the home.

If "Your work is unbeautiful, alright let it be unbeautiful… It is the experience and hard work of every day which alone will ripen in the long run and allow one to do something truer and more complete." Vincent Van Gogh

The oppression of women is different from other oppressions in its entanglement with intimate human love. A large portion of the harm of oppression can come through people who are close to us. Countering such negativity can come at great cost. Paraphrasing Tillie Olsen, Silences, 1978 p.258

"The pulses of light were not more quick nor inevitable in their flow and undulation than were the answering and echoing movements of her sympathising attention." Thomas de Quincey on Dorothy Wordsworth in 1827. Quoted by Tillie Olsen p.214

"I can't believe that by accident of her death all of her unspeakable tenderness is lost to the beings she so dearly loved... One can feel forever, the inextinguishable vibration of her devotion." Henry James Notebooks 1882. Quoted by Tillie Olsen p.215

Aspirant lives clogged in Love's ambuscade - their sense of their own potentialities, their self-confidence already robbed..." Tillie Olsen, p.218

Harsh art was no use to Joan. She sought joy and escape from unbearable responsibilities for things she couldn't change. She wanted to share the joy she got from painting colour and form.

"The *rapture*; the saving comfort; the joyous energies, pride, love, audacity, reverence in wrestling with the angel, Art." Tillie Olsen p.172 Silences

When I visited I would show interest in what she'd done and ask questions. She was always interested in engaging with her recent work.

'Sunflower'
Joan Colnbrook.
16/8/2018

Geranium
Jean Comack
19/3/2015

25 October 2018

25 October 2018

1 February 2019

13 December 2018

13 December 2018

'Octopus' 10 January 2019

'Blue and White Vase' 24 January 2019

'Posy from the Garden' 23 May 2019

When Joan was young, living in Bramcote on the Derby road just outside Nottingham, there was a lack of affordable paper - in fact there still was when I was young in the '50s. We used to draw on the back of used blueprints my dad brought back from the Aston Martin Lagonda works in Feltham where he was a draughtsman. So, anyhow, Joan's solution to this paper shortage was to remove a picture from her parent's living room and to draw on the wall behind the picture! Then to replace the picture so the new wall drawing was hidden. When this was finally discovered I think she must have got in trouble, although at the same time Daisy and Sid must've been impressed by her determination to express her art!

The story always stuck in my mind. She was willing to risk the wrath of her parents to make a drawing.

'Flowers from the Garden' 6 June 2019

18 July 2019

'Swirls' August 2019

September 2019

The place of paintings - finding the right place for a painting is something that is really messed up by our art system or rather by the allotted role of painters within this system. A lot of good paintings are stacked up in garages and attics while a lot of blank walls impoverish our public buildings. There is a demand for art but there seems to be no way to get the work to the blank walls. No-one knows where it's stashed and how to get at it. Its an educational matter too - as to the benefit and value of art on walls for all walks of life. Its not all about investments and white cubes for the few, who, as Daisy might have said, when it comes down to it, 'don't know their arse from their elbow'.

During this period I also made two videos. The first was about the embroidery we rediscovered stored in cupboards whilst clearing her house. This had been made by Joan and her mother Daisy years previously. The second video, with my son Lech and his son Ivo, was of us singing for her in her room.

Some of the responses to these videos are on the following pages. There is now a third video about her painting. Following the text about the videos there is a piece to accompany a tape-slide piece about her housework that I made in the Eighties.

Silk Roots

197 views • Mar 1, 2017

Stefan Szczelkun
56 subscribers

This is a video about my realisation of the global reach of my mother's and grandmother's silk embroidery. I am depicting a hesitant thought process; a tentative making of connections; a realisation that these 'ordinary' working-class cultural practices are deeply imbued with the wider forces of history in a way that came into our family by touch rather than by reading books. People said:

"It was lovely and very moving" Rita Keegan

"Very beautiful... What a lovely little film" Chris Jones

"Just beautiful!" Tracey Moberly

"Wonderful :-)" Leigh French

"Delicate and poignant" Michael Kemp

"Beautiful film" Marijke Loder

"I love how personal & reflective it is - and the embroidery of course." Carrie Supple

"Very gentle and moving" Catherine Yass

"I really appreciated the film - visiting my Mum today and we watched it together and talked about her and my grandmother's embroidery and her Aunty Edie who was especially accomplished and whose embroidery silks and tablecloths passed to whom." Susan Croft

"This is great – very sensitive and made with care, in every sense. And reminds me of the kind of the earlier work that you made with/for the Polish community – bringing bread to them, meeting people on their doorstep? – in its generosity of spirit. But a hard work to make too I think, in that "the both aspects" that emerge are what England struggles with now. The generosity and warmth, the inventiveness, and yet the remnants of colonialism and the ways it was taken to heart, or was just all-pervasive. Both at work." Simon Pope

https://youtu.be/7c1l7R55oSs

"I liked the visual richness of the material and your openess, vulnerabilty, gentle humour and hesitancy in the sewing box scene and the unspoken sense of losing your thread with your mum.
I liked the end credits too but would have liked them up longer.
Your question 'Can we respect?' touches on the deep roots of Whiteness that still feels entitled to assert its imagined and normative superiority by 'othering' black people symbolically reducing them to an infantile harmless object in order to overcome the deep fear of black people and their potential to rise up against their white, albeit working class oppressors. The badge is a symbol of the insidious hegemony of post-war racism and the extent to which working class interests can be aligned with the ruling classes. It is a really authentic and personal video." Chris Frank Saunders

"I like the way that it draws a line between personal stuff and great big abstract things." Jon Eden

"I so enjoyed your little film. It's very evocative, with so many memories sewn into those flowers and figures and the box of threads that all our mothers used to keep, with oddments inside like the old marmalade brooch." Sally Ingram

"It's really good Stefan, the detail and enormity both contained in the small things.
It also gave me an idea for a great big compilation of clearing parents/ home houses, so many friends are having to do this now." Sally Mould

"Oh, it is very beautiful. and allowed me a cry.
and not just working-class women Stefan, middle class women, I have the same history in boxes of my mother's, and her aunts. Embroidery crosses the classes, women's work, hours of silent work, at home, unrecognised... folded neatly in boxes -
Women everywhere making fantasy, beauty out of colonial hardship.
And I love the different tones of your voice, and seeing Joan... Thankyou." Emilyn Claid

"I loved it. It had me in tears at the end. Your mother feeling the work with her hands...It was like a junction between the romanticised memory of the past, its reality and today's actuality. Those embroideries pieces made from women during the most dark and brutal years through the war were a way to embellish the grey look of the world. Whilst their fathers, husbands and sons were fighting for their country, these women were fighting to rebuild their communities and keep the spirits up!!! It really inspired me to take over those respectable embroideries by writing or embroider messages with passive aggressiveness intents or fear. Almost as a projection of those women's thoughts whilst working. I don't know, this is the story I imagined! Well done. I was left wanting more. I will go and take another look at those pieces you offered to me..." Amy Dignam

"I just watched it and it is so brilliant. Gentle but extremely radical. I love your appreciation of women's contributions to the world." Susan Harris

"It is a beautiful film - I really loved all the wonderful close-ups of the threads and tin boxes and hearing your voice making the cultural connections and how racism is woven into our history. I particularly liked seeing your mum with the piece of embroidery and her asking whether Maya ever did any sewing." Emma Cameron

"I've only just watched Silk Roots. It's beautiful. I remember my Scottish granny doing embroidery. Yeah totally undervalued." Maggie Nicols

SHOW LESS

Mary Prestidge
Lovely movie and to see you altogether. xxx

Micheline Mason
This is just the sweetest film. Well done all. Joan was obviously enjoying even with closed eyes.

Lucy Adams
Brilliant!!

Emmanuelle Waeckerle
Really lovely and touching on so many levels. Her big smile and exhausted yet dancing hand says it all. and I love that spinning record transition !

Wendy Forbes-Buckingham
Fantastic - thanks for sharing. Lots of love to all xx

> **Stefan Szczelkun**
> Love back atcha **Wendy**!

Andrea Hill Davies
Brilliant ! just love it , so moving but fun also , love seeing all your generations together and the beautiful little girl's reaction to the song 'run rabbit run' and the happiness despite this illness of you all

Paul Tarrago
This is a lovely document, Stefan. One of the most life-embracing videos I've see in a l-o-n-g time... a home-movie high point!

> **Stefan Szczelkun**
> Praise indeed from the master! Thanks **Paul**

Brandon Spivey
Stefan that's lovely.

Melissa Hyatt
This is beautiful! Xxx

Lucy Marryat
So moving. Joan remembered them all. Good on you guys. You could call yourselves 'The Generation Guys and Gal', and go on tour.

Lucy Marryat
I have watched this many times - it's a classic. Ivo picked up that the blackbird had turned into a bluebird, how confusing is that Ivo?. I didn't understand that the rabbits were made into pies **Stefan Szczelkun**, how terrifying. I'm glad Peter Rabbit got away at least. No rabbit pie for me.

https://youtu.be/hL329wLlu_U

A third video was made in 2022 with the title 'Dementia Painting'. The main sequence of this was of Joan doing a late abstract painting in her carehome. Again I was fortunate to get many appreciative written comments.

https://youtu.be/WzkrnFljOGU

The housewife as a class pretender

The image to your right is from a set of slides that document my mum doing her housework in the Eighties in 84 Manygate Lane, Shepperton-on-Thames. This is where we lived from 1959 when we moved from Feltham.

In Britain in the mid C20th many working class women, who identified as aspirational rather than 'common', aimed to emulate a middle-class lifestyle. The mission was to achieve 'respectability' and shed associations with the common and vulgar. They became housewives in small suburban houses, but without servants - they had to do all the work themselves. The shopping for furnishings was on a tight budget and the decor had to be mainly DIY. Hosting was miniaturised into an occasional Sunday roast for the in-laws and coffee mornings with a neighbour or two. There was no money or space for pretensions to modernist quality beyond G-Plan furniture in the living room and American style Formica surfaces in the kitchen. Hoovers and other machines made the labour load manageable as long as the number of children was kept in check.

But even when this was achieved the working-class escapees faced another hurdle. The truly middle-class women had servants to do the actual housework. They could have time to play the roles of managers, elegant hostesses, shoppers, interior designers and so on. In the working class version the woman had to do everything herself, on top of the childcare. This often resulted in a 14 hour work day. The effect had to be achieved within a strict budget which might allow for linoleum but not carpets. The newly invented machines for washing, hoovering and cold food storage helped the workload, and women were inventive with ways of furnishing the house on a tight budget. Traditional crafts of dress-making and embroidery continued, with the husband helping with painting and decorating, house repairs and motorcar servicing at the weekend. Having morning (instant!) coffee with a local neighbour substituted for the more lavish afternoon teas and social dinners enjoyed by the wealthier middle-class.

In 2015 Vascular Dementia allowed my mum at 90 to escape this hollow ambition, she literally forgot it! And she seemed to enjoy living communally with very few possessions. The housework came to an end, but as we can see, she still made art!

At the start of the C20th the Deutscher Werkbund had faced an exasperating contradiction in their drive to bring modernist notions of taste to the domestic sphere. Middle-class women had reigned supreme in the home whilst their husbands were out making money. As I mentioned above, they managed all aspects of the home, organised the shopping and were elegant hosts in a network of social events that used these private houses. Some of these women wanted to become designers, some to even be architects, but the male theorists of the Werkbund saw the women's preferences for schund (junk) and kitsch as the main barrier to them being part of the effort to impose modernist thinking within everyday life. "To prove herself as a professional, the woman designer had to banish the ghost of Christmas fairs past." p.145. Then when some women who had achieved 'Sachlichkeit' (objectivity) designed a 'Haus der Frau' for the Werkbund exhibition in Cologne in 1914, it was still criticised because its austere modernist lines were seen as *not feminine enough*! The 'Haus der Frau' was subsequently excised from Design History.

The Werkbund's goal was to "impose middle class taste across German Society" p.141

However, as the Twentieth century in Europe went on, the allure of *schund* was hard to resist. Things! things! more and more things! Stuff accumulated from all directions from jumble sales, to hand-me-downs, to petty inheritances. The "tactile pleasures of excess, heterogeneity and disorder", were the true aesthetic of the C20th, as commodities accumulated and 'trickled down' in a profusion of accumulated objects. "In the thick stew of bric-a-brac, one could immerse oneself in the visual and tactile pleasures of excess, heterogeneity and disorder." p.135 Despina Stratigakos. It is ironic that it took the dreaded dementia to relieve my mum of her myriad collection of *schund*. When she lived communally in a care home she missed those things not one bit. They were the first things to fade from memory. Also ironically her painting went from intricate detailed still lives of things to much more impressionistic and, dare I say, modern. Her communards liked her painting and she was rare in having a productive skill amongst her peers.

Notes

* *Haus der Frau* material from Despina Stratigakos in her 'Masculine Reason of Feminine Spirit', *Partisan Canons*, ed. Anna Brzyski 2007

* Margarete Knuppelholz-Roeser was the designer of the *Haus Der Frau* in the Werkbund Exhibition in Cologne 1914.

* Deutscher Werkbund was a government sponsored organization dedicated to the promotion of German-made products and designs. 1907 - 1938 when it was closed by Nazis. Influential on modern design across Europe. In turn influenced by the English Arts and Craft Movement via Hermann Muthesius who was the author of the exhaustive three-volume 'The English House' of 1905.

* For arguments on how the Werkbund promoted its taste from a social class perspective. See: Mark Jarzombek 'The Discourses of a Bourgeois Utopia, 1904-1908, and the Founding of the Werkbund', in Imagining Modern German Culture: 1889-1910, François Forster-Hahn, editor (University Press of New England, National Gallery of Art, Washington, 1996), 127-145.

…in the case of housework the situation is qualitatively different. The difference lies in the fact that not only has housework been imposed on women, but it has been transformed into a natural attribute of our female physique and personality, an internal need, an aspiration, supposedly coming from the depth of our female character. Housework had to be transformed into a natural attribute rather than be recognised as a social contract…

Silvia Federici

1974

https://www.blurb.co.uk/b/11327186

The Art World

The fine art world surveys all the art made, grabbing only what it considers the top 1% to show in its prestigious uptown galleries. It also keeps most of this art away from the public sphere, putting it into storage or selling it to private owners. At any moment only a fraction of it is on display to the public. The professional artists that come to rely on the art world also self-select what they shows in the public domain, in the best interests of their careers, and by that selection amend their truth.

The other 99% of trained artists get other jobs or are directed to community endearment projects. The larger world of amateur artists is content to show its art on the walls of its own houses and those of close friends and family, selling a few pictures to local buyers. The trained and the self-taught artists have no sense of entitlement to a critical apparatus or distribution network, so much of their work gets moved into the attic and from there, finally, to a skip. These are mainly unframed works as the cost of simple framing is about half the value of an average amateur picture.

My brother and I really felt this when my mum moved out of her house. Only a few of her artworks could find a place in our own homes, which already had pictures on most of the walls. A few others went to her friends and a few more went with her to the care home.

Meanwhile most public art galleries and museums own a great deal of art of which is managed by a closed world of art professionals. Such municipal galleries rarely have democratic or inclusive committees to guide their acquisitions and loans. There are no traditions of committees on councils to find and display work from local artists. There have been little or no efforts by industrial unions to fund and display art from their members. At the same time the exclusive art world does not fulfil my first condition of a healthy culture. This condition is that cultural works should help us to evaluate our current conditions. This cannot happen unless *everyone* is involved. The 'fine art' world fails in this crucial task because its gatekeepers and the interests of its patrons limit its scope. Amateur artists are limited because of internalised feelings of not being worthy or intellectually competent; plus feelings of needing to be limited to the restricted range of imagery of the class fraction the artist 'comes from'. The sociologist Pierre Bourdieu mapped these class assigned layers of imagery in his sociological study Distinction (1979).

Grayson Perry's TV *Art Club* gets more than 10,000 entries from which they select a few dozen works to show on TV. Friendly Grayson assures us that he is very discerning and hard to please. He is an insightful curator who knows what will make an inclusive and diverse show that accords with the needs of mainstream media producers. Selection by the good and great is still shown as essential in spite of collectives like Exploding Cinema showing that a vibrant culture does not need gatekeepers. Nevertheless, in spite of its pervasive exclusivity, Art Club can still give us a glimpse of the scope of working-class creativity in spite of the hundreds who must be disappointed. As Tillie Olsen says: 'The tree still bears fruit!'

Most working-class artists, producing something original, are not really interested in selling their work for £50 plus £50 for the frame because it is usually an intensely personal production that is unlikely to be repeated. But they might give it away to a friend or show it in a place that would show an interest and treat it with respect.

"Works of art disappear before our very eyes because of the absence of responsible attention". Chekhov, quoted by Tillie Olsen p.169

I was reading. Harry M Solomon's book,
The Rise of Robert Dodsley: Creating the new age of printing

"Formerly controlled by patronage and state censorship, the world of letters had been shaped by an oral, aristocratic, amateur, authoritarian, and court-centred tradition." book cover blurb

Before Dodsley 'created the new age of print' he was a footman, a lowly servant. He wrote quite a bit about being a footman and it reminded me of my grandma Daisy and her years of service before my mother was born in 1926. She never talked to me about those years of service, and perhaps I was too young to see the significance of them in the '50s and '60s. But what I did take-in at the house in Bramcote, Nottinghamshire, that we used to visit two or three times a year in the Fifties, were two rather grand paintings that were in the front parlour. This was a room at the front of the house that nobody went in! It has all the fine crockery and some bits of nice furniture. Everyone lived in the backroom all the time. The parlour was unheated and it always seemed to be cold. The only time it was used was if there was a funeral; or a wedding; and people came round dressed up-to-the-nines. Then a few bone china tea cups and saucers would come out and people would sit perched on the armchairs with their little fingers sticking out as they held the dainty cups up to their lips. Well some of the Hyacinth Bucket types would.

There were three large landscape paintings in this room. When I say large they were about A3 in modern sizes. These paintings seemed out of place, and quite magical. In my memory they had ornate old gold frames. The pictures within these frames were watercolours of English landscapes.

They were heavy, the heaviest pictures we have by far. The gilded frames are not as ornate as I remembered them. The watercolours are very well made and feature what seem to be ruined palaces or former places of worship… perhaps a priory, with black birds rising out of the ruins. Echoes of Henry VIII and his dissolution of the monasteries - my mum converted to Catholicism. Landscapes of an England freed from papal bondage and the dominance of Latin scripture? The state in charge of religion - one authority not two? Or could it be more radical, thinking of my recent study of Spinoza, and be about country people's memory of a pagan religion with deities emanating from nature. Could this be Spinoza's 'Deus Sive Natura' or 'God is Nature'? Truly the beginning of a secular world. There is a peace and harmony in the human figures and the cows at rest. and the bland windless skies do not convey the social turbulence that a foreboding Constable sky can.

Like the great John Constable these are also images of a country life that my, essentially urban, grandparents had recently left behind along with its rural culture. I've written elsewhere of my Grandpa Sid's violin, which hung on the wall, unplayed.

"In political parlance, the Opposition was the 'Country' as opposed to the 'Court' party. Criticism of urban corruption was taken to be synonymous with the censure of Walpole, and the corollary symbol for an uncorrupted England was the countryside." Solomon, 1996 p.57

They were also examples of 'high art' originals. Daisy had got them when she left service - I'm not sure how. When she got hold of these works some of that upper class culture she had witnessed so intimately, was finally possessed by her. Artistic value stolen back into the working class parlour. My own version of this occurred in Amsterdam c2002 when I found a triptych of Marc Chagall prints and realised that I had just enough money to buy one (less than £100). Possessing that print seemed to be a toe-hold on a world that was mostly inaccessible to me.

My mum Joan, born in 1926, grew up with these landscape paintings in the background. Their singularity in her home must have had an intense effect on her. Not so much in the specifics of their content, but more, what Barthes called third meanings. An alien aesthetic. Abstracted from the actualities of the immoral sources of their wealth, the upper classes represented a torrid heaven on earth to people like my granny Daisy who, as a servant, had lived as a silent witnesses to their

rum goings on (Daisy's phrase). A life in which all the finest products of human work could be collected in private domestic environments, rather than museums in which we are all allowed to view samples behind glass. Her parlour was a bit of a Palace. Palaces were cold but full of art.

The dream was inert. Like the front parlour it was held at a distance. Like an analogon of what the afterlife promises us in heaven, similarly disembodied, and ever distanced, but somehow still comforting a persistent mental ache.

The fact that these paintings were produced by ordinary human hands, and eyes, and imaginations must have struck the young Joan. Joan, perhaps at some point long after these painting had sunk deep into her mental landscape, must have realised that she… she could learn to make such paintings herself. Make very similar paintings, even if she couldn't put them in golden frames and get them shown at The Royal Academy. The local art clubs annual exhibition at the Shepperton Summer Fete would have to do.

As I said I had these thoughts as I was reading the book by Harry M. Solomon. In it Dodsley expresses the mental ache of class exclusions well;

"How grating must it be to the soul of an ingenious man to observe all he says unattended to, his expressions ridiculed, and all his arguments despised and thought inconclusive, only because his coat is not so clean, or his wig not so much powdered as that of his antagonist?"

He opines that "Poverty is the Gulf in which all his good parts are swallowed." The footman was the lowest of servants in spite of his smart uniform. And there was a whole literature devoted to ridiculing footmen. For such labouring people, "education was acquired second-hand, if at all, and its lack was felt most acutely by those who subsequently rose to eminence." p.17

It was natural that their intellect would make the most of what they quietly witnessed without comment on a daily basis. Waiting at table the young Dodsley would stand behind leading writers like Pope and listen in to their conversations.

Jonathan Swift was sympathetic to servants, but Daniel Defoe was not, and had published a tirade against servants' insubordination in 1725, just at the time that Dodsley had escaped his unbearable position as an indentured child apprentice and had 'risen' to the lowest rung of 'Servitude'. Dodsley wrote a spirited renunciation of Defoe's 'Opprobrious railings, and spiteful invectives against the pride, laziness, and dishonesty of gentlemen's servants.'

"Defoe regarded the movement toward greater emphasis on a wage based contractual arrangement as a degenerate and dangerous revolution. He dramatised the conflict as the insubordination of surly servants against frustrated, frightened Masters." p.14

"Domestic service was the biggest employer in the 18th century; Over one fifth of the population worked as domestic or household servants." p.12.

The principle enshrined in Daniel Defoe's 'Great law of subordination considered' (1724), worked as rigidly in the home as in society. And in the hierarchical distinctions that most of Dodsley's contemporaries assumed were essential to the maintenance of social order, footmen ranked near the bottom. When Dodsley arrived in London, the usual yearly wage for either a footman or a lady's maid was 6 to 8 pounds." p.13

However, the job of footman was one up from the half-starved and ill-treated position of the indentured apprentice that he had been before.

Alexander Pope was the first writer to realise the potential of the Copyright Act of 1709, with his translation of The Iliad by Homer in 1714. This law allowed a writer to move out from under the heavy hand of aristocratic patronage towards the 'freedom' of the marketplace. Which reminds me of the artist William Hogarth c1724. Dodsley was supported by Pope and followed his lead to take charge of his publishing contractual arrangements. Dodsley became a very successful publisher himself, on the basis of the literary contacts he had started to make with the good and great whilst working as a footman. In particular it was his job with Jane Lowther in Whitehall that did the trick of getting his intellectual gifts discovered by the fashionable elite.

Bibliography

Servitude: a poem, Dodsley, 1729

The Footman's Friendly Advice to his Brethren of the Livery, by Dodsley, 1730.

The Great Law of Subordination Consider'd; Or, the Insolence and Unsufferable Behaviour of SERVANTS in England Duly Enquired, a 1724 pamphlet by Daniel Defoe

Guerrilla Girls of New York formed in 1985 and known for wearing gorilla masks, are the most influential group to protest the inequality of women in the Art World. "Do women have to be naked to get into the Met Museum" is one of their famous poster slogans from 1989. Since 2005 they have been commissioned by Major Art institutions and one of their posters is selling in the Tate Modern shop in London.

Ridykeulous appropriated Guerrilla Girls and Tate appropriated Ridykeulous

Joan entered WW2 as a 13 year old schoolgirl who had become a nurse by the age of 17 in 1943 and was tending to war wrecked bodies that had arrived in the Nottingham General Hospital. Her father Sidney had got out of the mining industry after the General Strike of 1926 and worked up his green-grocers shop in a garage; starting by selling potatoes grown on his allotment from a bike in 1927. In this shop in a garage in Bramcote, Sid found himself at kind of social node in which messages might be passed on, help found and gossip filtered. Brian Clough was the son of a newsagent next door (a proper shop not a garage) - aspiration was in the air.

Sid's wife Daisy had acquired these two water colours by the respected and prolific artist, James Orrock (1829 - 1913), from her decade or so in service, latterly in a bourgeois town house in Nottingham, and previously as a pastry cook in Upsley

Castle, in Yorkshire. A time of breathing in the atmospheres of high culture.

The pictures were a slice of that high Art culture that were an apparition in the setting of her end of terrace house on the Derby road. There was an dissonance surely, but they also had some bone china cups and a couple of pieces of dark wood furniture to make the unheated front parlour a kind of simulacra, a shrunken version of the domestic interiors of the higher echelons in whose mysterious life they had things called leisure time, surplus money and, most elusive of all, they were distinguished as a better class of person by having 'good taste'.

For this reason alone I don't find it surprising that the young Joan acquired a passion for art and an aspiration to paint.

SILENCE! - the great silencing of British working class culture

This book continues the themes of my Conspiracy of Good Taste (1993 - 2017) with new research and expanded terms of reference. It is presented in a full colour graphic format. The central argument is that there can be no ending of class oppression without a fully supported working class culture in every sense media.

165 x 165mm 105 gsm paper, Standard colour. 84pp perfect binding paperback. Illustrations: 30. £9.95,

ISBN 978-1-870736-22-0

Plotlands of Shepperton

Stefan Szczelkun

With a Foreword by Judith Tucker and an Introduction by Chris Saunders.

27 thumbnails, 38 full page photographs all in Premium colour. 52pp 165mm x 165mm Paperback. £12.95

ISBN 978-1-870736-24-4

Reviews here: https://stefan-szczelkun.blogspot.com/2020/10/new-book-plotlands-of-shepperton.html

Ingram Content Group UK Ltd.
Milton Keynes UK
UKHW050640260323
419123UK00008B/123